Why the Assembly Disbanded

Why the Assembly Disbanded

Roberto Tejada

Fordham University Press New York 2022

Fordham University Press has no responsibility for the
persistence or accuracy of URLs for external or third-party
Internet websites referred to in this publication and does not
guarantee that any content on such websites is, or will remain,
accurate or appropriate.

Fordham University Press also publishes its books in a variety
of electronic formats. Some content that appears in print may
not be available in electronic books.

Visit us online at www.fordhampress.com.

Library of Congress Cataloging-in-Publication Data

Names: Tejada, Roberto, author.
Title: Why the assembly disbanded : poems / Roberto Tejada.
Description: First edition. | New York : Fordham University
 Press, 2022. | Includes bibliographical references.
Identifiers: LCCN 2021054449 | ISBN 9780823299256
 (paperback) | ISBN 9780823299263 (epub)
Subjects: LCGFT: Poetry.
Classification: LCC PS3570.E435 W49 2022 | DDC
811/.54—dc23/eng/20211117
LC record available at https://lccn.loc.gov/2021054449.

24 23 22 5 4 3 2 1

First edition

We spoke in the zero code
system of assemblage and separation

—MICHAEL PALMER, *SUN*

Contents

1. Society of Alternate Belonging

 Two Guardians 3

 Anvil and Bellows 5

 Elevator Invention 8

 American Household 10

 Why Fear Heights 12

 Delayed or Modified 13

 Or Why the Assembly Disbanded as Before 14

 Lost Continent 16

2. Amend, Delay, Curve, and Disquiet

 Baraka Inscape 23

 Film Noir: Telescope 25

 Freeway 28

 Nightshade, Camouflage 30

 Escena 32

 Freestanding Form 34

 Beyond Reckoning 35

The Transport Hours 38

Mortar and Method 40

3. Kill Time Objective

Color Wheel | High Water 47

Kill Time Objective 49

Liquid M 51

Venus a Polygon 53

Indivisible Continuum 54

Vanishing 62

Envío 64

List of Illustrations 69
Notes 71
Acknowledgments 73

1. Society of Alternate Belonging

The work takes place underground . . .
where the possibility of uniting all that
is separate occurs.

—GLORIA ANZALDÚA

Two Guardians

My words were sent underground to where the toggle switch detonates.
That was the glare our voices were avoiding. There was something also

broken about the obedience of this retainer. The arcades weren't
semaphores just because the arrows leading there facilitated those

of us in line as though reliant on east or west quadrants. The ticket
master was prone to elide requests from the travelers, the sliding doors

sounded a fanfare for the common man, get faster as thought, or mind
the gaps. What I infer can never altogether establish a space adequate

to the body count. The platform motivates two guardians who were
instructed in safekeeping to usher me from harm's way but my stand

point so recedes from this tableau as to acknowledge a footprint
perspective. Translucent envelope inside remaindered by the riptide

or such tunnel vision as to warrant arrest. Why I was sent to the nether
world inflicted with no wound. Someone lets fall a pair of zip locks

containing the crystal bliss of this conspiracy; what I had to say was
sent, I mentioned this I think already, underground switch and toggle

intended to ignite what I could never bring myself to mean. Where
the voices were avoiding me—hands outstretched at quarter day to hold

back the beam—was there something broken? I weather compliant. I rally.

Anvil and Bellows

In all manners Mister Tourniquet intoned attention turning to my treatment
Many times ignored
Many times identical to the carbonate castle
Many times in tribal paint
Unbridled scuttlebutt stargaze releasing children
Palsied in germinal burst

Surface made of metal Missus Skeleton Key: it's a cruel copy
Tantamount to the emotion precinct
Tantamount to the other story imprint
To the opposite self complete with pigment, actually
Archaic catalog of chattel and usufruct
Whose characters include—
Professor Blind-Eye-Turning
Sister Bulletproof Jacket
Reverend Dead Man's Gully
Mister Secretary General of the Global Farm Security

Birth lines intersect here with the turnstile attorneys
Whose testimony pictograms a timetable

Into gossip and gainsays the evidence of animals
So menaced by what surrounds
These laws with mindful hand and fodder
As to inaugurate the weightless stranger
Brothering this imbursement
With alleged orders that stain and stoke
That ever more extricate our ancestor
From wonders one and all The End

Then the final credits run with life-forms
And we stray either from intimacy
Or the accident part
Emerges between miniature
Movement and application
Austerity and surface
Superposition and plane
Oh river palms and clock face
Stairwell and flagstone
Aspect of an outline
Verily over Landscape
With Gazebo adding
Bethlehem rose
Or clump green

 Wax-warm layers of synthetic skin,
Meat-muddled anniversary
Involuntary bromide book bound to inlay the marriage of word paste
And tooth pull
 Domina, this minion font and frontage
Over putty in pages
Reproduced by

Lower quadrant anvil
Vertical bellows and antelope
In upward red
 Quick quick! the syllables to stagger
The enumerated forethought
As when cobalt woodwinds issue silver pearls

Elevator Invention

...

Language-learner fearful of error as to pronounce the Americans as partway back from the dead devoid of the primary sources, phrase in semicircle, who could tell by the handwork, lever left by the glass-piece, radiance by flexible curve and grommet. Safebox at the stroke of twelve, and in the Georgian corridors by chance, packs of the catatonic lunge at an impasse, parlor room systemic, medium upright, aria into ectoplasm, new day complications on the October watch, small indulgence in favor of the notary.

...

Humanoid specimens connected by tubes in the cabinets submerged with the telling of How the Earth, how the morning quadrant waned, cerulean eddies from the logbook. In the submarine breathing, apprehensive sibilants from the sea fern Helvetica upend the seasonal epitaph, the liquid missive exercise to interrogate the colors known to poetry of 1810, or by follicles from the lunar anthem.

...

I wear the geometer's monocle when, at the turn of the century, as from the Ironworks where the Great Illusionist performed the spectacle of Jupiter and Mars, on display are a hundred bolts of houndstooth, a tinker's windup key, some knucklebones as from a butcher, and benzene procured from the corner pharmacist, a squadron of half-moon carriages pulled to the Factory, the fated horses flogged by petty criminals along the overcrowded boulevards so named for the Belle Époque as The Doll Maker's Dilemma.

...

Heliocenter unsteadily again, effect that outweighs the impediment, particles of triple fruition from the star clouds in Stalingrad to the enzyme driven mutations that make, as we know them, the senses obsolete, deleterious pattern of code, undulating surge of fluid, the offices of— suddenly everywhere—this heuristic insignia a suspension bridge, my dose of sodium pentothal proliferates a slaughterhouse assembly line to conveyor belt and circular saw and I am every seventh aster.

American Household

Here I'm untethered, or else this American household is.
A shame for guest and resident alike, torn asunder,

Immovable, unmoving, horizon line before it closes
On the embankment, which is too a slowing thunder.

Whether cash & cake were meant for us the undeserving
Is a frenzy of thought, an amusement from the spoils

Of corporation able to outweigh the will unnerving
All restraint from the madness or immodesty that coils

Each milligram back into the sky blue oxy addiction
McKesson, Cardinal Health & AmerisourceBergen

Manufactured for the painless end-to-end encryption's
Other plum for which we are to wait again our turn in

Line and still the others keep cutting ahead of us here
The complected & other-tongued asylum-seeking

Assembly of the glad in ordinary deliverance from fear:
First fuel in the plot that turns us into tyrants unspeaking

Yet another dream to make them do what in wakeful hour
Is lawless for us depraved and still deprived of power

Why Fear Heights

Looted homes. A few deserted by fire abruptly red after
I'm given to detach all the Technicolor film stock

and all the items capsize in outrageous dictation
with what I crave for the coming decade.

Property subject to seizure. Now phonic, now
phosphorescent whether fourscore and seven

to overestimate the next great task remaining. I want
a sequence so insane with pleasure as to impose

its excess on public speech leading all on Friday
to be intentional before the verdict, analeptic

for the next eleven arguments and discerning ever
in our feeble dispute. In this I was meant to rejoin

on charges to the sentence Why fear heights

Delayed or Modified

Faculty of the animal inclined to action ever suspect
or delayed—and then we modify the rule of law.

Criminals encoding glossy accidents in the ether
all the granulated dashes lunge

and promise elongation. Someone to
justice attack and retreat

someone awed by the acuity of mood. Attunement
by degrees in proximity to a world

where hope and worry tussle with such twin attentions
as time or trust for what

in punitive terms was my entanglement.
I have now the method for loss in the republic

immeasurable word it is all-involving

Or Why the Assembly Disbanded as Before

Hosanna in the borderline cinderblock warehouse, as much applause
as possible to collapse inside an ambulance now that conveys

The intravenous bags and bottle holder, twenty-seven stones
from here to the Idyllwild to the gun fields

It's a place you find automaton nurses who labor
in green-grey subterfuge, in all-over stripes

A round of punches to the lower jaw for my part in the main
so I get it now I'm the chosen one for reassignment

Face so altered as to beguile. This is enemy-convenient a
purview suitable to very new cosmetic methods.

Question is the admin diazepam and other hypodermics
were they counteractive or now consistent

With enough cases as to compel canvassers to anticipate
first signs of panic, sleepwalker antecedents

Tray tables in upright position, crushed ice out of open
mouth, air-conditioned ward redolent of superstores

And tattoo shops, or was it morphine sulfate in protocols
applied to disable the congenital twins?

Here's the world news: to junk-science prizes wax-candy
lips intone a flawless if always accented sentence

The kind of talking from another world where my mother
was Marlo Thomas and there were rival techniques

Contributed to the celebrity of my seven-sided disappearance or
was that all my enuresis when I doubled in size

As from her pocketbook, adorable but already diminishing?

Lost Continent

[after Rubén Ortiz-Torres]

Prismatic light-beams and motion to so enhance the monuments
encouraging society, goliath in its seizure of the earth people
former technology of bone, dawn's incessant yowling, renewed skin

a sort of liquid flesh: that we wish, even as tutors conveyed
the alphabet to faraway townships—need, even with our rhetoric
of puzzlement, faith overturning this makeshift enclosure

this great asylum in the ancient city of the Indies—to salvage
our nation from disgrace and despairing not, to us was tendered
the mistress builder most suitable to bestow the colossal head

on ground shuddering, all day blood and gold great mother
as when we found it, no longer migrant, holy in the highest
glory, honor and renown to Her most worthy everywhere

throughout all ages and generations, amen. There were two kinds
of breathing in the night; one that was jelly-colored and semi-solid
the other stunted in rapture or awestruck in such unbreakable blaze

as with incense and coagulates, to the artery, to cells that dividing
did duplicate, divide and duplicate again: cross-eyed, very close
to the triangular nose, upper teeth in baskets and bundles

like a shipment of newspapers very old admission stubs a cheap
notebook—all things artless, half real anyway—if a casket
if a prankster effigy, reflected face in a thousand interlocking

parts of what followed from the center point where I am
outside the fiberglass capital as in the one it beckons from a middle
order meaning. Out of isolation and forth to the deputy recitalist

of myself in surrogate space, precise eye of a properly positioned
witness like the visitor contained by sound full ceremony
perverse in aim as even this strange novelty's current role was

no how natural in relation to the person of the world I was
but a careful construction in the urgent theme that was a single
death, in the modest epic most immediate of our demise, I mean

recall, translucent and disposable, the remaining corpses. World
that was smaller then. Were we so immune to escalation had
there been more to fabricate in the lost continent, and to relay?

I acknowledged the cranium from the old populace and paid
my tribute to the new passing reference in degrees of routine
or memory as was prone to fit on gossamer sail. "The laboring

populace had lost its faith," bemoaned the boatman. "You work
if you intend to eat, already by mizzen truck with the factory
vanguard a millennium or two of meteoric growth in on-shore

commerce while the class struggle, while the opposing Party
adored the technocrats who made vulnerable, ignored best practice
inauspicious to the earth folk who bestowed us no distinction

as with the likes of blue-collar wage labor output production lines
given to befriending fire hydrants and phone booths, from the hard
workers at the local megastore to the lot of us wretched who

learned to accept your differences and embrace our flaws."
Boomtown hub, big-money high style and ostentatious wealth
long replaced even in the labor union. "I used to think 'model

worker' was the title for ordinary bodies that toiled hard rules
and regulations notwithstanding," the racketeer reported.
"But now 'migrant workers' like me also merit the distinction

proving once again the elected culture populuxe in the atomic
age meets the Temple of Inscription's slogan to oppose reelection
of the General stripped of revolutionary nuance Temple of the Sun

telling Temple of the Count to salvage Temple of the Foliated
Cross sharp at the oncoming ax blades of Aqueduct wind glint
the vertical distance relative to the reference point of an edifice

projected onto a plane vertical to Temple of the Lion
sleep bundled mouth wide open as though to bellow in siren
Structure XII, phase six devoid of shading, ritual appended

to official documents chiseled to a rhythm other than my own.
Because they feared the perils and aftermath in ways more than
they loved the light that would lead them sometimes asunder,

Dynastic-Novelty-of-All-Modern-Convenience to resemble
a product sold inside as the alphabet attraction of its architects
a theory, if I didn't doubt there was a God killed by coagula-

tion a land could so venerate as to amuse. God who? Not enough
to claim by open gashing of the solar plexus—queen's bishop
to Huitzilopochtli!—"I was awakened at one in the morning:

a terrible moan. I thought maybe thieves. . . . Rain otherwise drip-
ping all over this household, and still no arrival. I'm desperate.
Rainwater refusing to obey, if the drainpipe moans are ended

if only this, as nothing else." It was time for my replacement
mother (a cactus, flesh that wasn't flesh from the flaming mortar
of antiquity) to declare the northern desert exile for all measure

of paterfamilias: hyperkinetic emblem in saturated color after
the mash-up act between neighboring nations, arsenal of food
stuff and lower transit by request, sensations new to denizens

demanding entertainment of the ignited variety, cartoon cigar
that detonates to singe my face into an orifice too of blinking
light: or pyramid permitting matters—head first—to so decline.

2. Amend, Delay, Curve, and Disquiet

Tell me i'm dreaming
Tell me i'm hallucinating
Tell me i'm fantasizing
Tell me it's unthinkable
Tell me it's unrealistic
Tell me it's all in my imagination
—Jayne Cortez

Baraka Inscape

Not so for my republic nothing left of rule
Nothing left of rule over the salvage self

by way of weapon to sing in sovereign song
no more composed in courage than most

No more than most myself save nothing is
befitting the field with as many futile

stockpiles of opinion so moved to moving
with derision or memory's abortive

little heap after what I did to injury
Rooms still cold with the stroke of it

Still wreckage a resource like flesh
imputing fingers or lips I made stiller

unavailing even to eager asymmetries
of white where I am when I refute

in the kill zone altered of melodic lines
White in August heap's disintegrated glass

volcanic at the skeleton edge of that
pernicious unfiltered little self emphatic

for Baraka's Dusk for Duncan's Throat
for an advent in mind for the kinfolk

meant by all in the derogative mob
in land-locked earth in antipodes

in eyes-wide noncombatant number
in clay and kiln, in day and bone

in name an "eruption of a counterform
in the closed field of white definition"

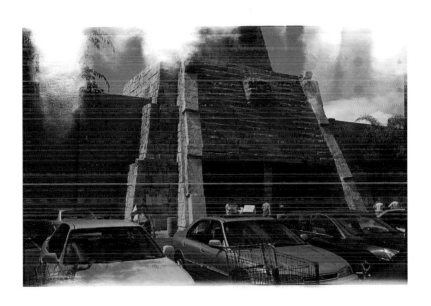

1

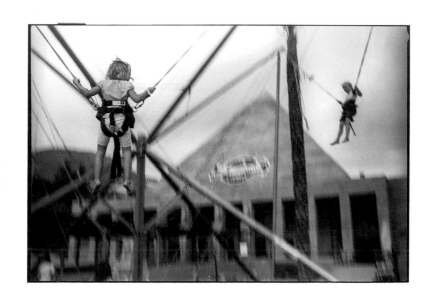

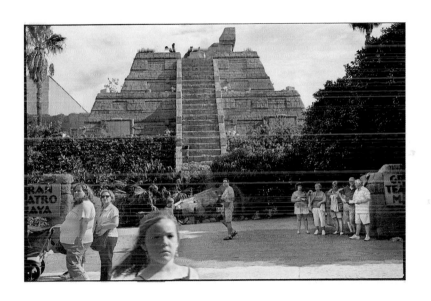

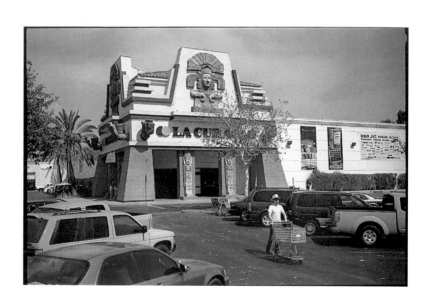

4

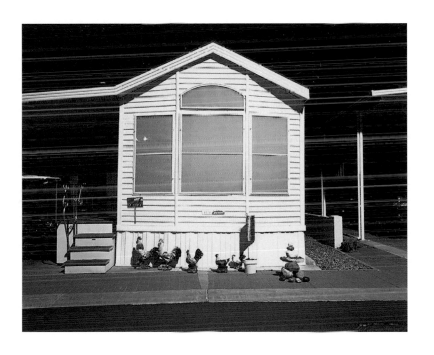

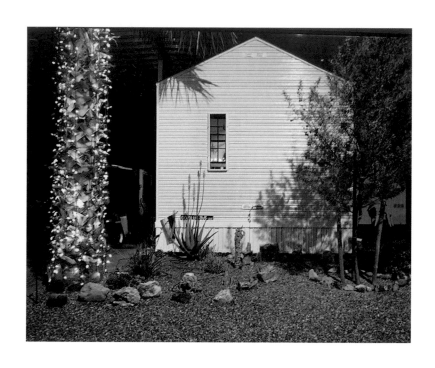

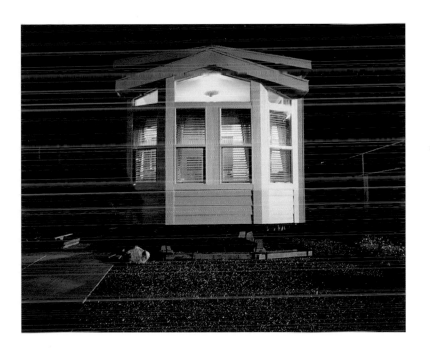

7

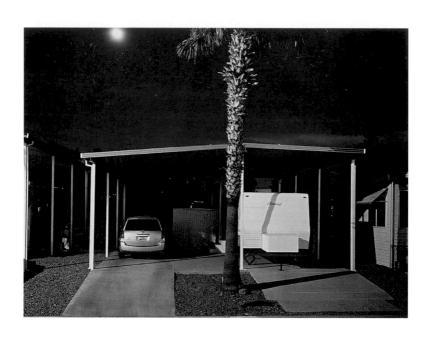

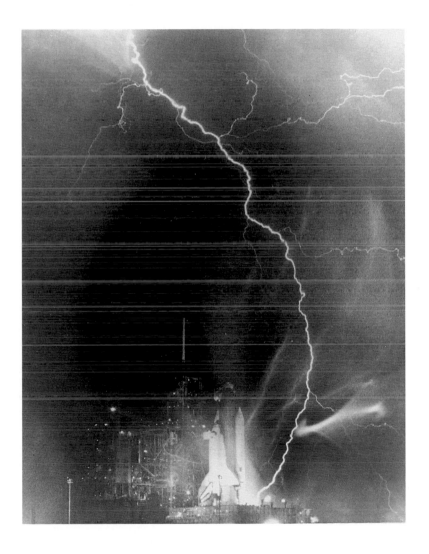

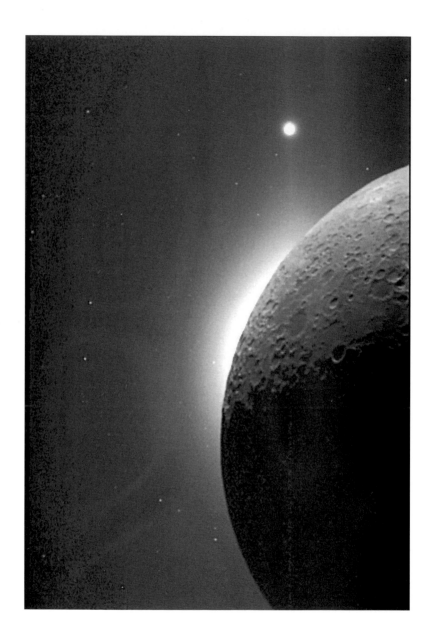

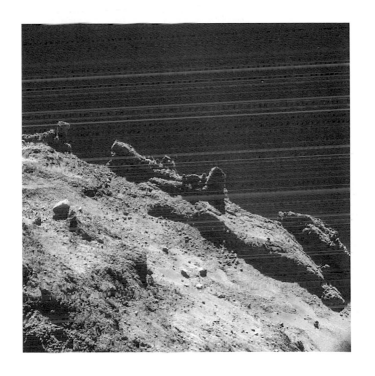

11

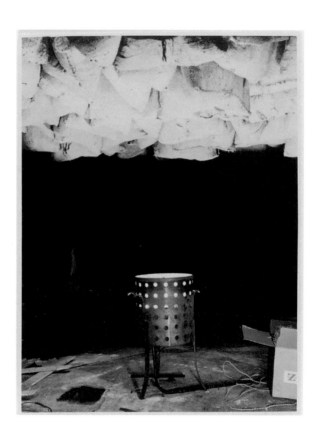

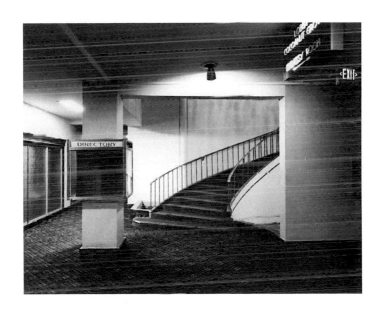

13

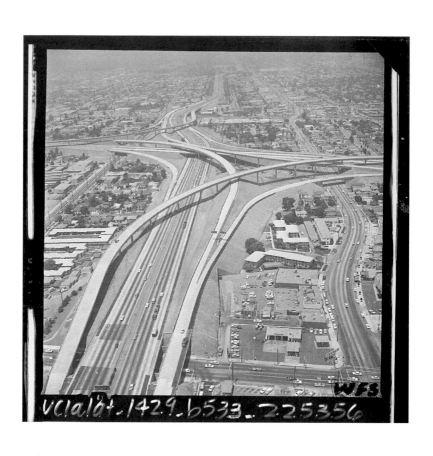

vclalot.1429.b533.225356

14

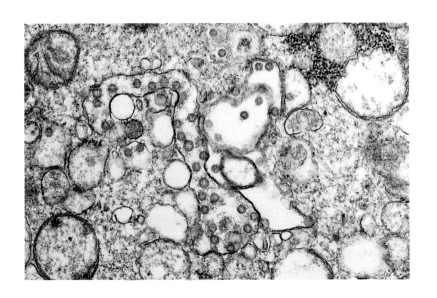

15

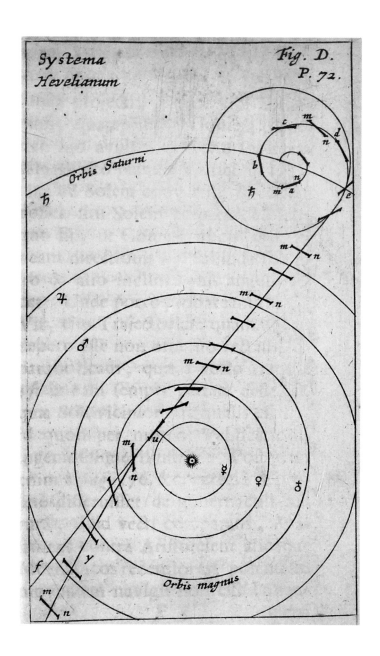

16

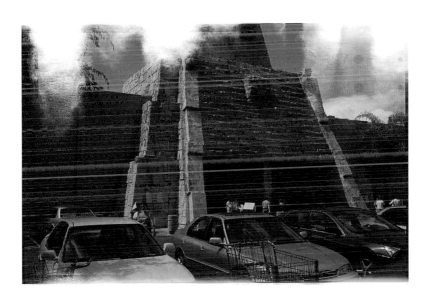

1

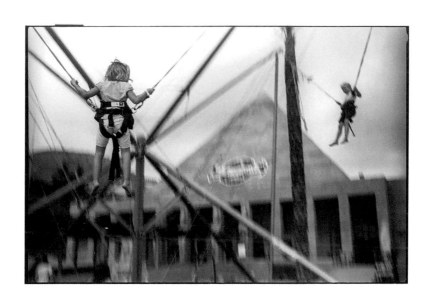

2

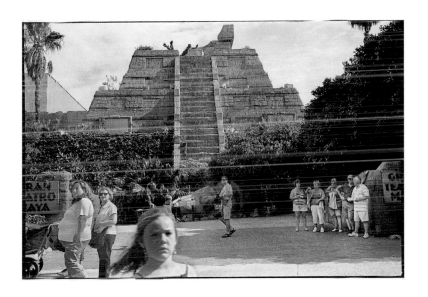

3

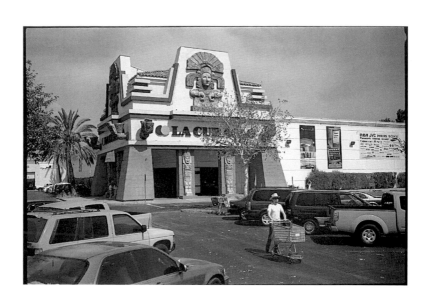

4

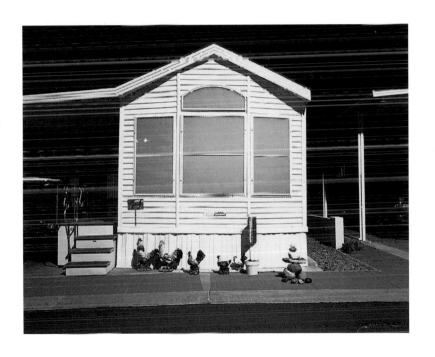

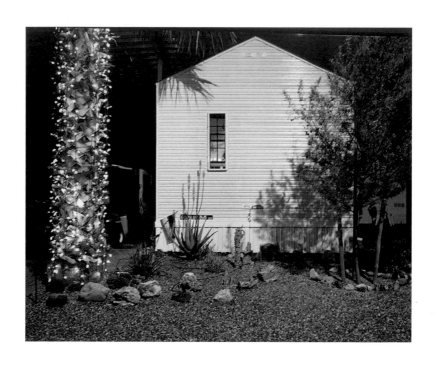

6

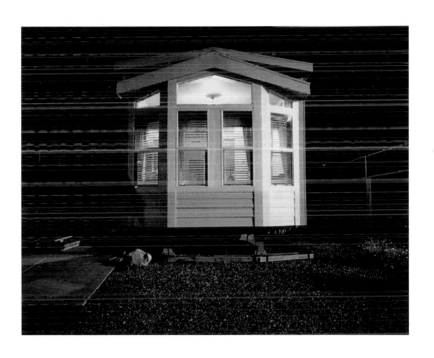

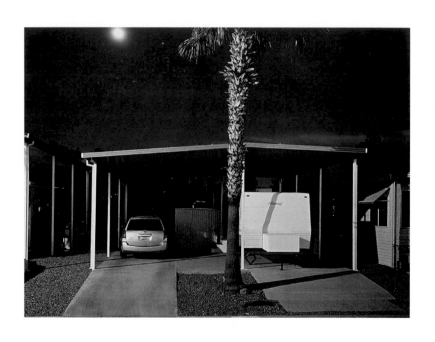

8

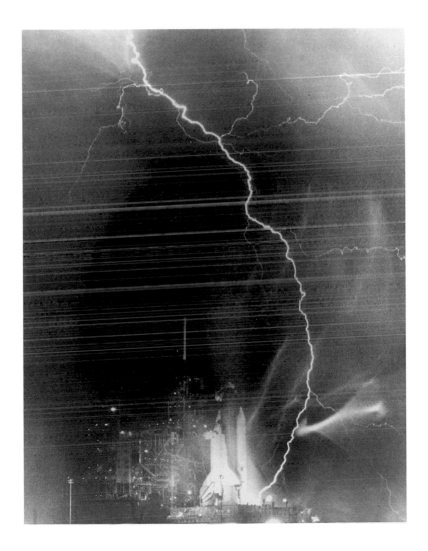

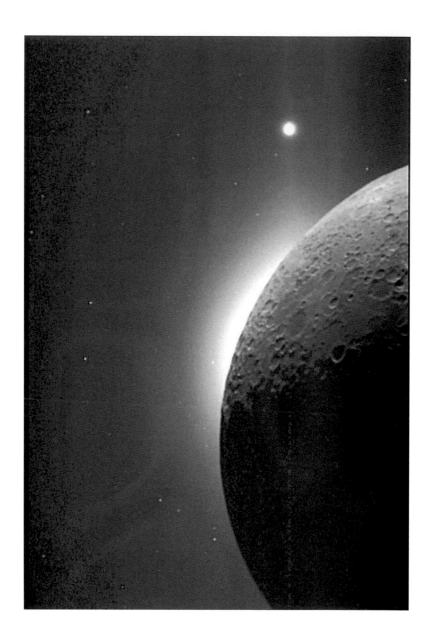

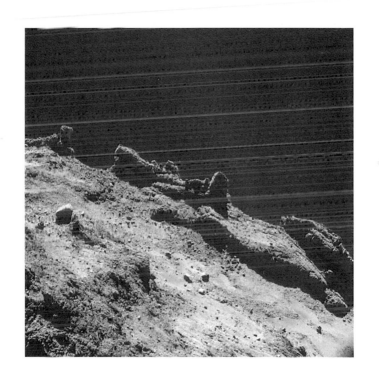

11

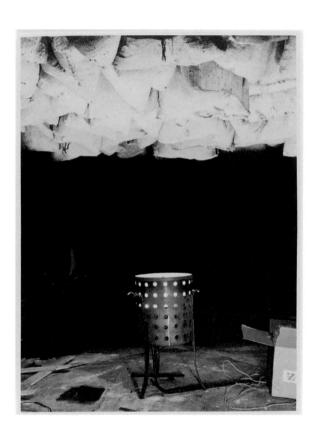

12

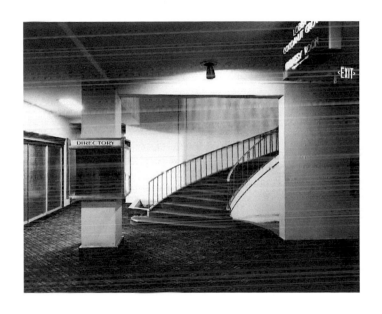

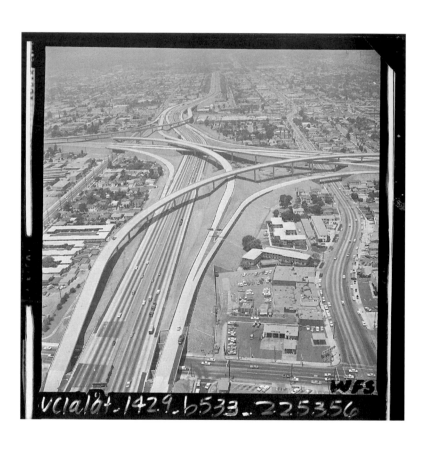

UClalat.142.9.b533.225356

14

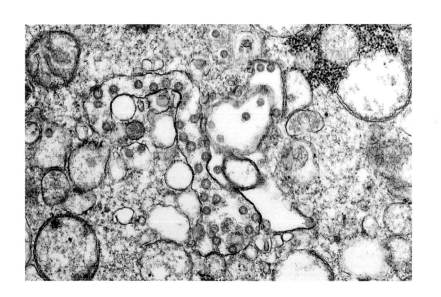

15

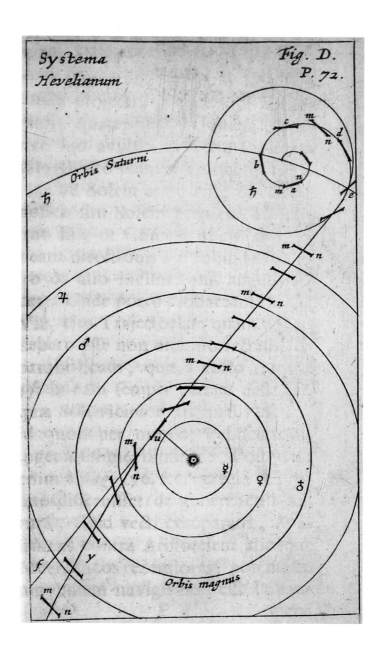

Film Noir: Telescope

When in "Bésame mucho" Nat King Cole intones all La Brea Avenue's
again a buoyancy of rye, dry vermouth, dash of bitters, as when

the congregated swayed at Swanee Inn—body weight to lunge
a slow one inhaled in common hold . . . *como si fuera esta*

noche . . . last chance departure to tumble this *última vez* when Álvaro
can idolize in Soledad her downcast blush perfected ice clink

accentuated traces of back-step pause arrested flesh touching
fabric with a hand insinuated flush-left on waist so pressed

against as to blazon into tremolo of lower back and clavicle
by cymbal scratch to dance and Mai Tai cocktails.

 Slurring
to strings resistant but for the pursuit of Los Angeles

if still distracted after all the invective: lime juice jigger
of rum in rain time *danzón* the month of March—sticks

and stones, glass-sliver cliff at road's end—whatever
else in camera lenta surrenders claim to conclusion in radio

words of uplift—a once and future sermon by Sister
Aimee on "The Sunshine Hour."

 And on the subject of my vanishing let me
add that by rack and narcotics held hostage in a shack at Agua Prieta

from the desert I was spared if God is my witness—the lasting brunt of
so much banter as volleyed over highballs at Don The Beachcomber

habitués alleging in the end she was buried with a telephone beside her
inside the coffin, by a couple debating over supper somewhere was

it lentils in Granada or frog legs in Uruguay and "I swear
if you don't put that thing away I'm leaving . . . "

 Again the aching pitch

it's Consuelo Velázquez her lyrics I mean from a window east
side of McCadden as though what don't get compressed

on this emulsion, see, every picture in your skull elapsed
tonight every motion prone to give it all away each

day from any switchboard in efforts to leave no trace, instead
from a telephoto lens . . . —point being *mañana* them Feds

is going to scize his mansion on Murfield—"Claim he
played every beer joint from Tijuana to Bakersfield . . . "

—bah, *Señor* delinquent taxes back at you from Havana if
it isn't the Bureau of Internal Revenue bent on taking

the deed to Hancock Park and repossessing the Fleetwood

Freeway

As much velocity as there are seasons of reward and goodwill, as little comfort
eligible as when the contours elevate and cradle, as many loyalties

connect to the pivot and pulses or as little light on two nations as meant
all times to be failing or as yet to succeed practical joke played as early

as the epigrams and flags for the priorities of leaving hoisted as late as
the death of a mood no one can really tolerate the pillar for posting

the crocodiles each cycle to cycle in drift and drag for historic view
claiming part and parcel at large in unflinching sweep the dinosaurs

and cosmonauts the glass refracted flash of exception chalk insoluble flex
or fidget the plan anathema pliant volume upended enclave of obtuse

enumeration or probable dissolve of the noblesse oblige complicit in
recline and ashes dormant combustible unknown to certify provision

ah my refundable appeal to policy on the grounds set forth administrations
consistent with the standards, constituent of all these immunities

but evocative of language that, having so made a pact with the night examples
as to indwell its daylight haunting, emerges in accounts undaunted

lines venturing to outdistance description if they are to comprise what they
evidence. It's no endeavor confirming the laws of physics—merged lanes

that double for hunger and time: memorial to deter the varieties abridged

Nightshade, Camouflage

Time to galvanize in measurements of emergency
your paperwork now with aptitude

Hidden universal law you let someone
else insinuate pretend to so devolve

as to possess a small equivalence maybe a word
for lunar quadrant maybe some other upsurge

Coastal strip for falling shell each hour
on the hour that only those who bolster by and by

The Firmament The Wain The Cleaver
armaments in a position eye associates

out of ether for days in camouflage for a throng
whose fatality you can pinpoint given

barley nightshade citrus fig: branching cables
irradiate the unsettled residences in grove

in low-lying brush in timberland and under
siege who know how longer arable

Escena

Signs of decline when pattern exposes overstrain
Something sutured for the sake of disconnection

*

Kitchen scene *Supper at Emmaus* later
Velázquez makes pause of *La mulata*

*

Inveigh against labor as an anecdote
Servant unsuspecting of the miracle

*

Time unmindful when lived as expectancy
Secondary self that emboldens the hero

*

All the concentration all the daydreaming
When applied to perfunctory work

*

Suspense and lines of discernible appeal
Habitual actions but only as ornament

Freestanding Form

[after Betye Saar]

Clock tower directive with a stopwatch Oath moan
status of a kitchen ladle brandished in one hand
grenade in palm grip of the other

Cushion combat thumb and wrist Homeland
shown enthralled of markets imploded also
by declassified fears my heroic

former name for someone else In household
wanted list discarded figure where it fits
to line the inside of a coral box

enhanced freestanding form In solid
gold demands of your small slivers
of it disproportionate to Washington

Beyond Reckoning

Admission here of my behavior

to dissemble a story about the victors

my quarter moon and crossbar

my factsheet glossy chevron

I'm enabled in place

as I never meant for Hamburg

or Brussels never Athens

no matter how I obliterate

my evolving thoughts concentric

with the fragrances of clean

and nearness to atrocity

a measurement of days

and progress in terms

I too obtain in amazement

sometime far sometime so

in the urban sequence inalienable

begotten ever of the million

chemical components

the color asphalt tawny

chlorophyll grizzle I confess

I suspect I unfriend

a shy electorate with something

notable like evidence or argument

something noble for the influx

of learning my lesson

in connection to belief

and what teacher tells me

with no mind to erasing

my purpose why forfeit

the cruelty of forms I accept

I concede I allow I discomfort

and are we now adjourned?

—o hear ye therefore ghost

and guest in graphite

timely untimely

The Transport Hours

[after Connie Samaras]

Held fast to the evolving horizon, whose upsurge encircled sooner
than it was possible to ascertain, before it had hovered there, a touch-tone
away; act now. For there, even in that brief appraisal—in agreement with
the roadway, with the motor home and trailer park—was conveyed the
promise of serenity and freedom; a completion. But there had come by then
a tremor in time between always striving to assert, oppose, not this year,
maybe next, to contend, the proximity of arriving, if in some way no longer
here in flight still from that expanding sphere, departure in the half tones
of a secret, wish for some vicinity, in a middle landscape not of this earth,
an ether not especially of our species, desert wakefulness adrift in the leave-
taking, double-wide the nights debatable in such vinyl glow advancing,
detached from the planetary management, this substitute revenue for all the
proper names.

So instated was travel in the continuum, flash expanse as though by
black light gels, dead end of the street for the only transport hour available
in the elastic state of imperfect clarity, center point of the story, its own
eviction, this time certainly, this time like the last demand to be apart,
drawn on such empowerment and skill as to guarantee survival, my body
now a chaos of excitement, a heat warp over all the improbable minutes
in whose duration now to be with the women I assume the powers of
mutation, the aptitude of animals, I duplicate, I meld with the binary
numbers, I so cooperate with the machines as to make myself invisible, I
sanction the authority of gravel, I indent where the layers ebb, I crossbeam
even as I contradict the pattern assigned to the surface of the land in lesser
accidents of stone and sky.

I merge the four directions into a solitary segment, I engineer the semblance of a habitat into the subject of hydration, I review the foregoing, I account for the universal crowd in the long withdrawal, I doubt the imperative, the end effect, there being some confusion as to whether partition was in reference to a present tense or somewhere in the distant shimmer system, back flash measured by the alliance of my mothers, in triplicate under the vapor light, flame story of the urban commons, inheritance of the dwelling notes, a passing-through of side-light for mercury in retrograde, semisolids for the global south, cathode haze over the settlement, means tantamount to the outcome, such looming as for the pursuit to be ongoing, evanescent, committed nowhere but to the temperature perspective.

Mortar and Method

From the viewpoint of method, even this pantomime-futility appearing as choice, is the incremental mind to suspend the shapeless succession.

• • •

If you alter the little crystalline music as to inoculate, future endurance no more equipped for the irritation—and there is your bunker.

• • •

Theater of single light source seduction over-reaching from the fluid sensory machine to cross-question; now remove your hand, now swallow—

• • •

Shade and half-light surrendered in the target of attention if key words to a code were a motor nerve quickened only to the thesis anatomy.

• • •

So I began my independent life in debt—television crash-landing into a pile of second-hand books, windup clock of fiction, counter-terrorism.

• • •

Solutions said to vary widely, make fitful, body now a porous achievement of water, limpid follicles, and what they called the picture skin.

• • •

Change in the porous nature of it already moving past us this landscape of haze and hopefulness; mumble as by imminence, incoherent progeny.

• • •

As when the oldest star of the galaxy—verve phenomenon, my experiment in danger—I cross the triumphal arch, marquis of a visible diminishing.

• • •

Regardless of exacting standards—of a figure plausible in the pathology of portrayal—victors were quick to recast the sequence of yesterday.

• • •

Before deserting, even as floodwaters engulfed the star-port assembly, I surrendered my paper, The Sunlight Competitor, to the other engineers.

• • •

Time signature to the three modes of my diminishing inflamed public opinion with regard to the next syllabic reckoning of our lunar anthem.

• • •

Body-weight transistor for thoughts formerly outlawed: noonday choice between free fall paralysis or the missing pages from a picture-book.

• • •

Amalgamation of two sets of fantasies: twin who in the breakneck swarm outlives me; and my afterlife that "gave to feed and fed on feeding."

• • •

Inciting the species with half-elastic hieroglyphs for bait did my daughter unleash a lethal mass of glint unmoving in exploded space.

• • •

When applied to the humans who passed, for whom there were never ebbs as they lived, transparent, I detached now from the fluid expansion,

• • •

With new flesh for the nations to outlive the onslaught of my allowance—
archaic carbons a mile beneath the tar pools—was my endurance for the
undertaking.

• • •

And allegiances waned despite the craving to shape the entanglements that
came to defy the next life—long-emergent and still without form.

3. Kill Time Objective

Putting together such a language,
where many can also be one,
requires that the effect precede the
cause.

CHON NORIEGA

Color Wheel | High Water

1.

Neither memoir nor manifesto, and having a surface rough to choppy
intoxicated currents of coerced conformity; blue star casing, damage

without redress of law; liquids that conciliated sleep, saturated
in color phenomena, intensity of apparition or forthcoming fullness

of undercoat in flash and hue, measure of the capacity for occurrence
mounting in the crush and high water weight of wads unfolding

fraught with shifting lineaments of brow and air, brow and panorama
disclosure of strain that for times did favor glean forward shin splint

imbued with facts describing shuttle slips of filament and interval

2.

Of slender festivity, hours after the daybreak noise among noises now
consistent with the onslaught of accidental crash, circle's impending

cause, effect in every disavowal of its light source and music redolent
of burnt canyon and pasture, endeavor to escape the reflex paralyses

of night terror, make amazement give rise to banknotes by the millions
when banners line the avenues as circumstance turns promise possible

loud heart and holy smoke made moan for us all the thunderstruck
pine and eucalyptus chitter of finches taciturn token, hope a color

wheel daubed with slopped liquid and lacking formal cause, fastidious

Kill Time Objective

for the sake of my acoustic self I lead out of danger an anonymous pack
from the building entrapment secured by militia

first prompted was the mouth emission, other species techniques I
thought would never keep from me the village immolation even now a
third person plural to ask in a chorus concerned with all the unsanctioned
disclosures, we had expressed in such adversaries our interest, we had
divined from them a quantum of intelligence

soon adjusted of my amplitude I escape and striving escalate the only
barrier dividing inside from our thick steel at first translucent, gleaming
now but with a weathered crackle glaze suspending the ability to recognize
a likeness and I panic overjoyed or appalled, anyway the base line
exhausting the tonal pitch insofar as they see not my face, no matter how
close they look, first and foremost classified, chiefly management, mostly
disapproving

soon the phonic constellation after hours of the data harvest, room tone,
proximity to source, boredom of the solar system, estuary trespass

soon as maps were to the mirror sequence by leaning on the present,
complicity was to the frenzy of flesh, muddle of tongues, a ransom note

but for the sake of fighting for breath already the instrument for
transposition in a parasitic image finally proper to this place: I'm the

encryption I'm the statistic, no longer bristling in the heroics of metaphor, I'm equipped with artillery that enables me now to bullet an opening for everyone's deliverance

but for the scene change lodgings very disinfected, new cause for residing in that I trace it back to the assignment room and retrieve, because arson, what I misplaced anew and under observation now, two performers licentious but so approving of the spinal-chord perspective as to marvel at the sheer outrage and wonder of the surgical incision

but for the tangled purpose of the anatomy we take to name eviscerate

but for the conference hour this week with my parishioners in exchange for the motion in multiple layers—overcoat, many trousers, uniform— in the process also of my ballooning self into unprecedented scales of subjection

as soon as I recite the lines that tell the world of the authority to petrify to touch and be tutored or otherwise curb but never entirely embraced no matter the many hours we waited on Ledgewood to trust the day

but for the amassing body attributes of my contempt and retribution, but for the ever more audacious interference at the level of my molecular resemblance

but for the album now children please open to lesson thirty-two

Liquid M

From a radio haze of association there emerges
An assembly—teeming number of persons to a person
Always seeking to enhance with cruel insight
An attitude or viewpoint that submits I am
Nothing—a cloudburst of arms and digitation.
The assembly pointed its rotary ligaments as though
With flashing arrows to say look at the repellent
Little stain incriminating the deviant boy with my
Features and in possession of all my belongings.
I'd arrived from his displacements or he from mine
In a lament not of sorrow but of bitter obligation
To whatever it was the stain betrayed. But you
Promised I was able to discern from an audience
Each face suddenly half-obscured by this lectern
Serving as my foreign shell. Each so noted a form
Of agreement as to make demands and be anxious
For the former boy to proceed with my thesis.
I did I might have said of the tiny humanoid specimen
In place of the many pages I was meant to recite.
The biotic gel was a living system dilated thus
Into a nascent organ shape still attached to its source
Although aching for another measurement of life.
The assembly still waiting. What else but to remove

The thin protective overlays each one held together
As if by some internal gravity commanding all
The approbation of the resin heads in attendance.
Chattering swelled at the expense of the magnetic
Syllables in my lecture for which the boy returned
To provide radiant confirmation of an antithesis
One that made intelligible a world as it appeared
When temperatures from the rain day evaporations
Oozed as from the starting point. This was a problem.
There appeared a physical but weirdly porous
Boundary between inside and out as this juncture
Between an ability for speed to excite my behavior
And a belated quality of attention that recalled
A wild pageantry of pinpoints in dimming glow
Flimsy laws that narrowly commanded me to move
Forward with the sum total I collapse of liquid M.
Actualities of day made implausible other migrant
Episodes all conspicuous as matter out of place.
Boy and assembly disassociated from conditions
Wherein to thematize society in a synthesis about
The stranger even formerly excluded from a crowd
Was to incite the boy's impersonation of the unfamiliar.
He palpitates for an increase in affability and euphoria.
I anatomize for a burlesque of bloodstream combustion.
He gives good entrance in increments and transit losses.
In him there is deficient what I solarize from very near
In whose total composition every moment obtains.
At last he assembles with a series of modular parts
So many ingots and quarters for our present chances
That I ulcerate I discharge I dissent and make soluble.

Venus a Polygon

Occasion for a criminal all day the statute of limitation

Venus a polygon in the cloud-form battalion

Every pixilated scale of your skin in aerospace it radiates they swallow

As for the legislators who make barbarous and refute

They listless in measure to a person they requiem

Six times a map whether warfare was whether hygiene

They adumbrate and so betray as when the defendant

With blindfold off the squadron of history and into the dirty hole

Indivisible Continuum

I seem to be a verb,
An evolutionary process—
An integral function of the universe.
—BUCKMINSTER FULLER

• • •

In story, selfhood palpable as by time lapse; onlooker perception modified; wakefulness altered; view to the familiar landscape redirected.

• • •

Allegiance to outcome in excess of the evidence intoxicates because it comes to define the twin life already nascent but still without form.

• • •

In story, in the vicissitudes also of method and media—any ground for symbolic action in public—in knowledge obtained from the unsaid.

• • •

So the lucky break led us to be reckless, overhang favored by the council, fault line by dint of our mortgage, the oil field unincorporated.

• • •

Faced with the ineluctable severity of law and its link to dissolution: speech and concealment; breath-kingdom divided when opportunity falls on the third.

• • •

Same old ability to speak as ever, for whom acquisitive I exist alone in the privilege of my household, there's an image on the television.

• • •

Transposed photograph, two rooms: in one there's a watchman to guard the threshold; at the far end of the other, wakefulness as audience.

• • •

Return to the scene—posterior effect to cause what place is to the original—with an obedience whose compulsions appear identical to choice.

• • •

From the viewpoint of plot, even this pantomime-futility appearing as choice, is the incremental mind to right the shapeless succession.

• • •

Landscape foreboding when circumstance bewilders the faculties—figure incidental to—inconsistent with—what animates and halts in mid-motion.

• • •

Quiet pleasure in that blush of skin: modest avowal of what a word can confirm, moreover when it activates, encourages.

• • •

Performer committed, residual inhabitant, to an overtaking, to be rid of milk and ginger spur in ankle-deep inheritance, inaugural quartz.

• • •

Disdain and envy of the idols so submitting to my satisfaction as to favor me the mortar and method to raise a causeway out of estrangement.

• • •

Hard kernel in nightmares to convince it occurred at the quarry, our intent to find failing even now as shallow graves still map the desert.

• • •

Denied degrees of realism unearth the spillway, enough edible laver and dulse for fueling the gel objective to absorb the body shock.

• • •

Homecoming for that underground encouragement whose purpose it was to threaten with a counter-calculus of maul, blaze and smothering ash.

• • •

If in the brickyard, if in the chromium disclosure copyright, if in my signature all demise; draw closer, triangle, bylaw, some protein.

• • •

Even with slurred tongue and cracked teeth I discern a benign country beyond for me to confer there my night custody and coat of arms.

• • •

Same unfounded sensation in sight, same tenuous advances from my departure point ether in its sinuous release to anesthetize the galaxy.

• • •

Disunited I address the cascading scales related to valve let loose by instinct to account for being just one of an assembly's constituent parts.

• • •

A calendar that tenders all authority to this: cloud forest encouraging descent into the grasslands, and smoke throughout the length of time.

• • •

Believe me only on Tuesday, detachable, when I submit that descriptions were in upsurge: rodent abrading to suit the lowland democracy.

• • •

From an overflow in the storehouse for distress—prodigal aroma, inscrutable smile— came new assets to supervise before the next cessation.

• • •

The sunlight concern was with fraught amalgams of attributes; dislocated birthplace, weightless silver—for all the accounting, exuberance.

• • •

Redolent of past perfect convulsions, barbed curvature of energy, foliate-exfoliate grove, drape or flash festoon, sovereignty, its undertow.

• • •

Three-times kindled foundry torrents of liquid alloys that cool by cascade into the modest pills you ingest when the life story obsolesces.

• • •

Why, if it most resembles agitation, if all the same withheld—if a timbre insinuates its deviant hiss for throngs of unsuspecting listeners?

• • •

Skills for amazement in this vicinity adjoined to the condition of those who—chain, splinter, switchback—would alter the object of finality.

• • •

Consistency to defy the pitfalls of persistence, such outpouring—glaze, metal, foam—as to compromise my behavior in the tablet era.

• • •

A new form for spatial experience afforded by throngs, readied for the fusillade, poised to astonish, eventual phosphorous defiant of touch.

• • •

Inquiry of restraint, night places of dust-settled abandon—each quiet removal on the edge of inching cliff, its crystal nerve, to splinter.

• • •

So safeguarding a ground to inhabit—encircled rotation of grain, for example, after cotton—as for reverence, as when it reiterates, always.

• • •

According to ratio and legerdemain there comes a seizure that, whether by confinement or consensus, unleashes so many species in parcel and drove.

• • •

In the regime of curiosity, axioms incremental to, dependent on, coming after the set ways of arranging it all to so exist as a category.

• • •

Taken to emerge out of the slough and cinder, enough to oxygenate, minor life-forms, swellings that angle into gestures of hazy aspiration.

• • •

In my homecoming was the future moving to register an inventory of experience I deform, even as I deride what confines me to severed circumstance.

• • •

Was it already lost, always—first temper known to appear only in escape or distraction—what if long buried even as a halfhearted kindness?

Vanishing

Amulets that share a kinship in the histories of light and language when
I unite the number 9 to 27, the word tangerine to lemongrass, meadow
spur to thistle, glimmer to destello; drive that fades, splinter of duration
evanescing; double life conjured by vocables from a zone of repetition—its
glow at the origin, vision contingent at the level of the letter—all things
abrupt now intermittent. Claims singular never less than overstatement,
when I slip into view out of

joint with experience, when attributes of bliss and cataclysm reside not
in portentous totality, but in the ordinary detail, attention requisite for
me to tell the narratives of sight and sound in transformation. Discrete
words a partial view, but even as I surface—subject to predicate, at best
a proposition, belated reason "I" am the cause of my thoughts—why, in
the domains of the ether, in the pharmacology of everyday matter, in the
flattened contours, my singular life a social

statistic—is the charm not of narrative consequence, bestowed on me a
script of action as to navigate the intangible space of so much undigested
information? Rip in the web of meaning when I cast and draw, but owing
to that gash where to see is to know, am I careful in my unwanted thought,
in desires for such a gesture as to embolden, persuade? Limberness,
untangle the strict partitions without hazard to the shell protective of

all persons provisional in settings that reflect, I cover a ground, I quicken, I substitute the vanishing with constituent parts, regenerate, deprived of a halo, released from this fixity, am I not without radiance of my convenient forgetting and, everyday—because it so beckons—in the recurring custody of a world, around whose mindfulness we congregate, and over which we are inclined to argue?

Envío

The thing is pushed
forward. It is cold, non-symbolic.
So, nameless, as, say, animals are.
Unless.
These stray unlessnesses
Avert attention. They
Give solace to it.
—ANN LAUTERBACH

Lifted eliciting some
such climate this

animated open
form impassive

is an engraving on
ebony paver to

neutralize the prodi-
gious hammer in

charmed ignition
whose underside

fuses sand-sized
body-beads released

in cellular vapor-
cloudburst over

blue over surfside
baffled by this my

signature weightless
without shade or

reciprocity of pattern
forward-hover slant

into the upper zones
but at no apparent

endpoint or clef do
I cease in soft desist

Roberto Tejada

Illustrations

1 Rubén Ortiz-Torres, *Apocalypto*, San Jose, California. Photograph, 2007

2 Rubén Ortiz-Torres, *Heret-Kav She Who Is Above the Spirits*, Benidorm, Spain. Photograph, 2008

3 Rubén Ortiz-Torres, *Los indios de Barcelona*, Tarragona, Spain. Photograph, 2007

4 Rubén Ortiz-Torres, *Un poco de su país* (Paco's Dream), Pomona, California. Photograph, 2007

5 Connie Samaras, from *Edge of Twilight*. Photographs, 2011–13

6 Connie Samaras, from *Edge of Twilight*. Photographs, 2011–13

7 Connie Samaras, from *Edge of Twilight*. Photographs, 2011–13

8 Connie Samaras, from *Edge of Twilight*. Photographs, 2011–13

9 A powerful electrical storm created an eerie tapestry of light in the skies near Complex 39A in the hours preceding the launch of STS-8, 1983. NASA

10 Clementine Observes the Moon, Solar Corona, and Venus, 1999-06-12. NASA/Jet Propulsion Laboratories/United States Geological Survey

11 Jagged Horizon on Rosetta Destination Comet, 2014-11-11. ESA/Rosetta/ NAVCAM

12 Raoul Ubac, La plafond de Duchamp, 1938. © Adagp, Paris

"When the surrealists began drafting plans for their major exhibition of 1938, Duchamp was asked for suggestions. The idea was to decorate one of the trendiest galleries in Paris. The red carpet and period furniture were removed. The skylight was blocked with hundreds of suspended coal sacks filled instead, following insurance company recommendations, with lighter and less flammable materials." Man Ray, *Autoportrait* (Paris: Robert Laffont, 1964), 214–15.

13 Tom Zimmerman, Ambassador Hotel, Casino Level Stairs, 2005. Los Angeles County Building Survey Photo Collection

14 Aerial View of Construction of Santa Monica Freeway at San Diego Freeway Interchange in Los Angeles, California, 1963. Los Angeles Times Photographs Collection

15 Transmission electron microscopic image of an isolate from the first US case of COVID-19, formerly known as 2019-nCoV. The spherical viral particles, colorized blue, contain cross sections through the viral genome, seen as black dots, 2020. CDC/Hannah A. Bullock; Azaibi Tamin

16 Jakob Bernoulli, *Conamen novi systematis cometarum: pro motu eorum sub calculum revocando & apparitionibus prædicendis . . .* (Amsterdam, 1682), fig. D, facing p. 72.

Notes

"Or Why the Assembly Disbanded as Before": In *The Interpretation of Dreams*, Freud famously linked his own dream of Irma's Injection—and its latent content concerning professional malpractice—to the structure of logic affirmed by "a man who was accused by his neighbor of having returned a kettle to him in a damaged condition. In the first place, he said, he had returned the kettle undamaged; in the second, it already had holes in it when he borrowed it; and thirdly, he had never borrowed the kettle from his neighbor at all." The method serves here to mirror poetic forms of defense for acquittal.

"Lost Continent": The multimedia artist Rubén Ortiz-Torres (Mexico City, 1964) produced in 2007–9 a photographic series, "The Past Is Not What It Used to Be," with an accompanying text titled "A True Account Concerning Conquests of the New America" (*Mandorla: Nueva Escritura de las Américas* 11 [2008]: 29–46). This poem gives voice to those images and likewise configures a mirror occasion for reflecting the fear and fantasies prompted by metaphors of occupation, displacement, and counter-conquest.

"Baraka Inscape": In a brief 1971 essay Amiri Baraka wrote of desires for, and attitudes about, the engagement in action of a "personality as part of the total world community," of personhood in the geopolitical racialized imaginary from a largely Euroethnic base of operations. Thus, "a counterform in the closed field of white definition" marks the place where "Ethics and Aesthetics, as Wittgenstein sd, are one."

"Freestanding Form": References in "Film Noir: Telescope" and "Escena" link Nat King Cole and Sister Aimee Semple McPherson back to Caravaggio's *The Supper at Emmaus* (ca. 1606) and Velázquez's *La mulata* (The Kitchen Maid, ca. 1620) so as to read Betye Saar's *The Liberation of Aunt Jemima* (1972) from a seven-sided historical perspective.

"The Transport Hours": About her "Edge of Twilight" series, the photographer Connie Samaras relates that "this body of work marks a conceptual turn from looking at the future of imaginaries of global capitalism," reminding us that "twilight" was a pre-Stonewall code word for lesbian and appeared often in the title of pulp fiction novels from the Cold War era. The photographs—depicting homes at a lesbian separatist trailer park in an unspecified location in the Southern California desert—were "shot at night, often quite late, under the park's vapor lights," with film exposures lasting "2 to 4 minutes long."

"Mortar and Method" and "Indivisible Continuum" were conceived first as Twitter feed meant to exist in the ether along with the 24-hour information cycles and speculative futures—given "to feed and fed on feeding" (Muriel Rukeyser)—rehearsed on social media as our technological utopia's historical uncanny. "The future is here," in William Gibson's oft-cited remark, "it's just unevenly distributed."

Acknowledgments

Some poems originally appeared in the following print and electronic journals: *1913: A Journal of Forms*, *The Baffler*, *BAX: Best American Experimental Writing (2018)*, *Breach*, *The Brooklyn Rail*, *Cosmic Bulletin* (Institute of the Cosmos), *Harriet* (the Poetry Foundation), *Iceberg* (Mexico), *Jacket*, *Literary Hub*, *LRL5*, *Map Literary*, *The Ocean State Review*, *A Perimeter*, *The Poetry Society of America* online, *Puerto del Sol*, *Sentence*, and *The Volta*. Grateful acknowledgment is intended to the editors of these publications. "Two Guardians" and "Kill Time Objective" appeared, respectively, as an audio feature on *PoetryNow* (the Poetry Foundation) and *Voices and Verses* (Houston Public Media). "The Transport Hours" featured in *Connie Samaras: Tales of Tomorrow*, edited by Irene Tsatsos (Pasadena, California: Armory Press/Armory Center for the Arts, 2013). *Why the Assembly Disbanded* doubles as an artist's book conceived by designer Cristina Paoli of Periferia in Mexico City (2020), and as a video-film presentation: <https://www.youtube.com/watch?v=vNqvHEMb9nM>.

Special thanks to Alan Gilbert, Alfonso D'Aquino, Andrea Giunta, Andrew Zawacki, Amy Gerstler, Ann Lauterbach, Anne Waldman, Anselm Berrigan, Carmen Giménez Smith, Carolina Ebeid, Caitlin Murray, Chon Noriega, Claudio Leal, Connie Samaras, Constance Krebs, Cristina Paoli, Cuauhtémoc Medina, Dale Martin Smith, David Colón, David Dove, David Lau, Dorothy Wang, Esther Allen, Forrest Gander, Fran Sanders, Gabriel Bernal Granados, Gabriel Martinez, Graciela Iturbide, Hannah Brooks-Motl, Hannah Ensor, Harris Feinsod, Henk Rossouw, Hoa Nguyen, Horácio Costa, Irene Tsatsos, the Jack Kerouac School

of Disembodied Poetics (Naropa University), James Enos, Jan Wallace, JD Pluecker, Jeffrey Pethybridge, Jena Osman, Jessica Fisher, Jesús Macarena-Ávila, Joel Bettridge, John Culter Alba, John-Michael Rivera, Jorge Miralles, José María Espinasa, Joshua Escobar, Julie Carr, Kristin Dykstra, Lalitha Gopalan, Laura Armstrong, Luiz Nogueira, Magali Lara, Marco Antonio Cuevas, Marina Simakova, Matthew Stadler, Margaret Randall, Matt Flores, Michael Davidson, Michael Slosek, the Milton Avery Graduate School of the Arts (Bard College), Monica Youn, Nicholas Lawrence, Norma Cole, Omar Pérez, Paolo Javier, Peter Bermudes, Peter Ramos, Poets House (NYC), Poetry Project at St. Mark's Church, Prageeta Sharma, Ramón Gutiérrez, Reina María Rodríguez, Robert Fernandez, Robert Kaufman, Roberto Bedoya, Rosa Alcalá, Rubén Ortiz-Torres, Shana Swanson, Sherwin Bitsui, Simon Leung, Stacy Szymaszek, Stephen J. Ramos, Steve Dickison, Susan Briante, Suzi García, Susan Gevirtz, Tim Johnson, and Tonya Foster.

I cherish an energizing company of friends at the University of Houston, and I'm fortunate to share in the place of vitality they devote to making, knowing, and serving others. Similarly, I'm indebted to the magnetic fields of thought and action that Ronaldo Wilson quickens with startling artistry and generosity; contributions that broadened the range of possibility for this book. Thanks, foremost, to Richard Morrison, advocate of the critical imagination in its various shapes along the horizon of cultural inquiry. His support has been a source of encouragement over the years, as when the ground fell out from under so much human certainty at the onset of the COVID-19 pandemic. I'm grateful to him, to the entire editorial team at Fordham University Press, and to the particular care of Tim Roberts and Sheila Berg.

• • •

Secret lifelines make the words irradiate, a daily gift from Michael Bryan.

Roberto Tejada is the Hugh Roy and Lillie Cranz Cullen Distinguished Professor at the University of Houston, where he teaches in the Departments of English, Creative Writing, and Art History. He has published numerous volumes of poetry as well as several works of Art and Media History.